KA-BOOM! CREATE YOUR OWN HERO ADVENTURES

A BLANK COMIC BOOK FOR KIDS

YANCEY LABAT

ROCKRIDGE
PRESS

Interior and Cover Designer: Stephanie Sumulong

Art Producer: Janice Ackerman

Editor: Cathy Hennessy

Illustrations: © 2020 Yancey Labat

ISBN: Print 978-1-64611-726-0

R0

*To Eliza and Serenna,
my two little superheroes*

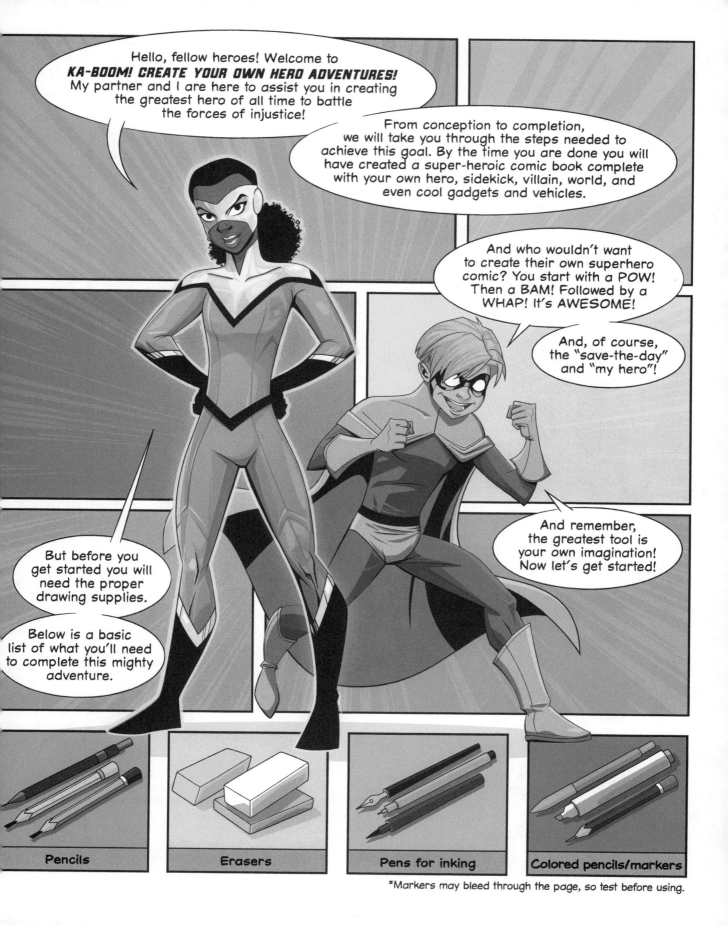

*Markers may bleed through the page, so test before using.

Sketch your superhero here

Now comes the fun! It's time to create your own superhero! At first it can seem a bit overwhelming. What should you name your character? What are their powers? Superstrength? Flight? Energy projection? All three?

Or maybe they can stretch and have extra arms and a third eye!

Exactly! Or maybe they don't even have superpowers. Maybe they possess advanced technology, like gadgets, vehicles, or an invincible suit of armor.

And you'll want to create a costume you love. After all, you will be drawing it a lot!

You will also want to come up with a cool name and origin story for your hero.

Who are they? Where do they live? Are they an adult? A kid? What led to them becoming a crimefighter? Was it something in their past?

Is there some outside force threatening their world? Is it for fame and glory? Or are they just being an upstander? Again, all of this is entirely up to you.

Sketch your sidekick here!

The supporting cast can be very important to a hero's journey. The hero can have an assistant, or "sidekick," to complement their abilities.

Keep in mind this sidekick doesn't even have to be human. Maybe the hero has a super pet, robot, or even an outer space alien.

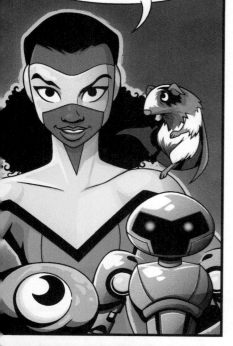

Other members of the supporting cast might include an elderly aunt, a local police officer, friends, family, or anyone in their community.

They become more interesting the closer they are to the hero because it makes protecting them that much more important.

Imagine and Sketch Your Superhero's World

Creating the world your hero lives in can be as much fun as creating the hero themselves. Many comic books have their worlds based in our reality, but this is your world, so have fun! We understand that creating a world can be even more overwhelming than creating your hero, but here are some examples to help get those creative juices flowing.

What is the name of the place your superhero lives?

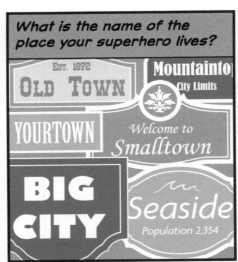

What does it look like?

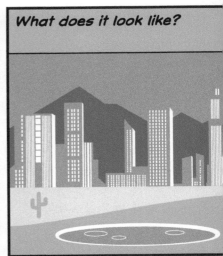

Sketch your world here!

What type of home do they live in?

Do they live alone or with others?

Are there any threats or conflicts in this world?

Imagine and Sketch Your Superhero's Vehicles and Gadgets

Sketch your vehicles here!

What's cooler than having awesome high-tech vehicles and gadgets? Not much, my friends. Not much . . .

These can greatly enhance your hero and look so cool.

If they can't fly, then a jet pack can do the trick!

Or a cool, sleek, tricked-out car that can transform into an airplane or submarine!

I'm sure you can come up with something even better!

Sketch your gadgets here!

Gadgets are great for the non-powered hero--grappling hooks, smoke bombs, boomerangs, suction cups, surveillance devices, you name it.

They give them the advantage needed to succeed in a world of superpowered adversaries.

What does your hero need to help defeat that seemingly undefeatable villain? Which, of course, brings us to . . .

Now we're getting down to business! Time to create the big bad. A great villain can make or break a story. They are nearly as important as the hero themselves! We'll need to understand why they do what they do and what they want to achieve and why.

No matter how many times the hero seems to defeat the villain, they keep coming back. They are there to challenge the hero. To make the hero think and come up with new ways to defeat their villainy.

One twist on the villain is if the villain thinks they are the hero and what they are doing is best for the world.

This can sometimes create a more sympathetic villain rather than the dastardly mustache-twirling single-agenda ones (who can also be fun!).

They should also have a cool-looking costume!

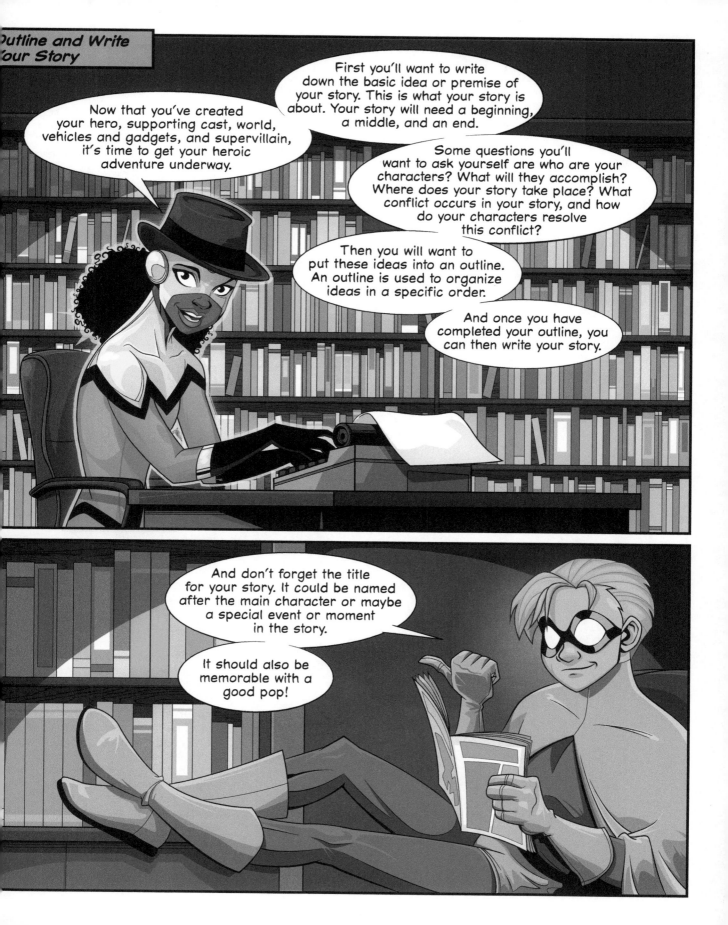

Plan Your Panels

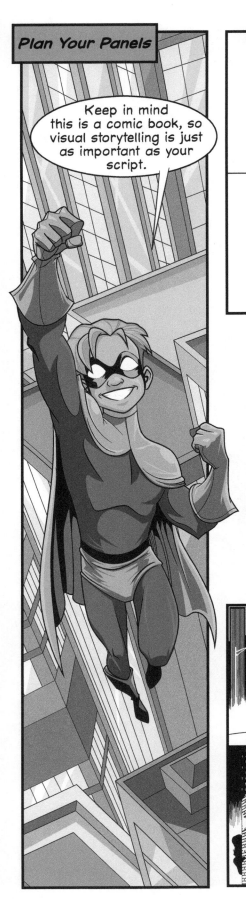

Keep in mind this is a comic book, so visual storytelling is just as important as your script.

How to Read Comic Book Panels

Comic books are generally read left to right, top to bottom, in a "Z" pattern. Each panel is a complete illustration drawn in a sequence. The goal is to be able to tell the story visually. Basically, it needs to make sense before the text is added.

Sketch Out Your Story

You may want to make thumbnails of your pages. Thumbnails are simple sketches of what your pages will look like. These should be done on a separate piece of paper. Notice the variety of angles and use of backgrounds in the example. These are both important in making your environments more believable and adding excitement to panels. Once you have an idea of your layouts, you can then sketch them on your page.

Visual Pacing

In this finished example, you have the establishing shot of me in my secret identity strolling through a city. The second panel shows a shadowy pursuer stalking the unsuspecting hero. The third has the ominous figure ready to pounce, and the fourth shows my "archnemesis" attacking! Or just tagging me. Here, the backgrounds are used to move the eye from panel to panel. The direction of the character's movement as well as the use of negative space are also ways to keep the page moving, which is crucial to visual storytelling.

Dialogue Balloons

Dialogue or word balloons contain, well, words. It's where you place your characters' conversations.

Some balloons can be stylized to fit the character speaking.

For example, if the character is a robot, the balloon can be less of a balloon and a bit more squared to distinguish it from a human balloon.

I am not a bot ...

Thought Balloons

Thought balloons show what the characters are thinking. They express the inner nonverbal dialogue.

Special Effects

Special or visual effects are also known as visual sound since comic books do not produce sound.

They can have a great impact on action pages or can depict more delicate scenes, like tiptoeing or raindrops.

Try experimenting with ways to make the lettering style match the effect needed. And that brings us to . . .

THUD! BAM! POW! doink! ZOOM!!!

Lettering

Sadly, hand-lettering has become a lost art. Many letterers have developed a style and scanned them in to create a font. But here we're going old school.

Practice lettering in the lines below

Inking

Inking is embellishing the pencil work with black lines for dramatic effect and reproduction.

Draw your character, ink it, then color it.

*India ink is not recommended, as it may bleed through the paper.

Coloring

Coloring is just that: adding color to your artwork, making it bright and beautiful!

Design and Sketch Your Comic Book Cover

CREDITS

LOGO

TITLE

ISSUE

IMAGE

COVER TEXT

Sketch your cover here!

Okay, this is it! Time to wow your readers! This is what brings them in. The cover!!! Dah-dah-daaaaahhhhh!

The cover should show an important part of your story without revealing too much.

It needs to be incredible, spectacular, amazing, and sensational! You want people to say, "WOW! I really want to read that!"

Well, I guess that's it. Our work here is done. Now turn the page and create your own superhero adventures!

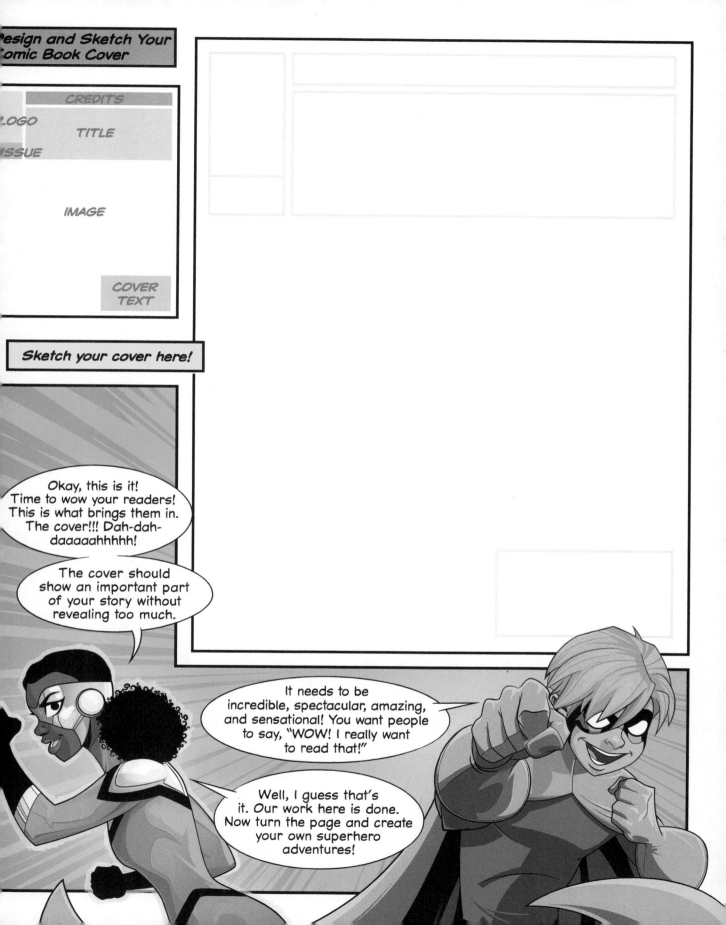

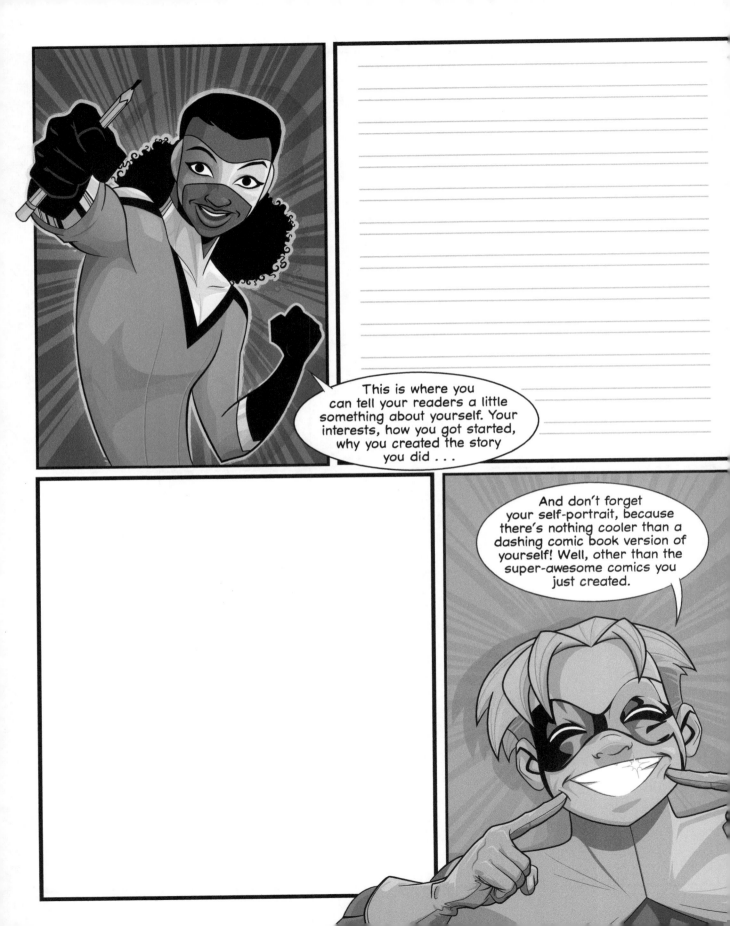

ABOUT THE AUTHOR/ILLUSTRATOR

YANCEY LABAT got his start at Marvel Comics before moving to illustrate children's books for many publishers, including Scholastic, Houghton Mifflin Harcourt, and Chronicle Books. He is the Ringo Award–winning illustrator of the best-selling DC Super Hero Girls original graphic novels and three-time recipient of Diamond Comic Distributors Gem Awards for Best All-Ages Original/Reprint Graphic Novels. He lives with his wife and their two superhero girls in San Carlos, California.